GW00865949

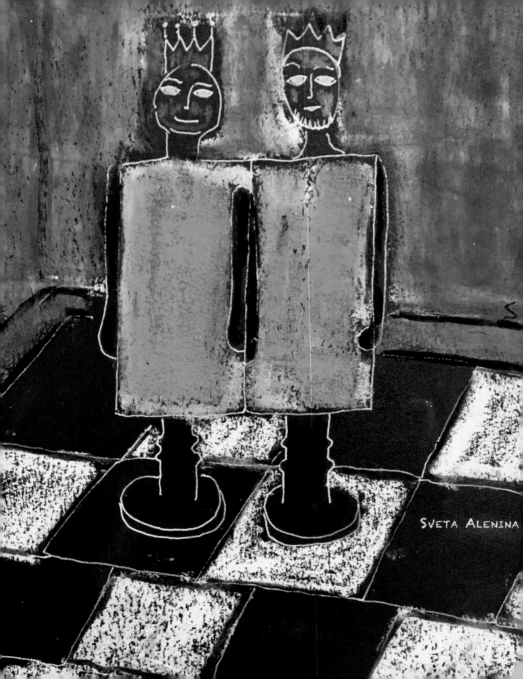

SVETA ALENINA

MAN'S UNCONSCIOUS FEMININITY

(f)

No less naturally, the imago of woman (the soul-image) becomes a receptacle for these demands, which is why a man, in his love-choice, is strongly tempted to win the woman who best corresponds to his own unconscious femininity woman, in short, who can unhesitatingly receive the projection of his soul. Although such a choice is often regarded and felt as altogether ideal, it may turn out that the man has manifestly married his own worse weakness. This would explain some highly remarkable conjunctions
CW7 ¶ 297

(g)

It is very difficult for a man to distinguish himself from his anima, the more so because she is invisible. Indeed, he has first to contend with the prejudice that everything is coming from inside him springs from the truest depths of his being. The "strong man" will perhaps concede that in private life he is singularly undisciplined, but that, he says, is just his "weakness" with which, as it were, he proclaims his solidarity
CW7 ¶ 310

PERSONA AND ANIMA

(h)

Now there is in this tendency a cultural legacy that is not to be despised; for when a man recognizes that his ideal persona is responsible for his anything but ideal anima, his ideals are shattered, the world becomes ambiguous, he becomes ambiguous even to himself. He is seized by doubts about goodness, and what is worse, he doubts his own good intentions
CW7 ¶ 310

ANIMA AS A PERSONALITY

(i)

Now, everything that is true of the persona and of all autonomous complexes in general also holds true of the anima. She likewise is a personality, and this is why she is so easily projected upon a woman. So long as the anima is unconscious she is always projected, for everything unconscious is projected
CW7 ¶ 314

Carl Awesome Jung.

I think my Shadow is sick of me spying on it.

 • Of course, of course, sounds good, - I say

And then I spy on this conversation.

I woke up feeling lower than low. Somethings is wrong with me, - I am confused. Traditional psychiatry says: ill, the new discoveries hint: creative, Jung adds: paying a price for being an artist. So all down I go to the Coffee shop for coffee. As I am paying for it - the bright sun comes out.

The saleswoman says: Oh! Did you bring the sun out?

And I am thinking: right :(- and she so authentically and seriously adds: Thank you!

And I am thinking: wow! People ARE everything! She JUST lifted a sun in me from the abyss.

One thing I've learned - when I LOVE my loved ones more than anything - Jesus comes out of Pandora box and swings His swords, as promised, as promised, as promised. And my Grief will excess my Self when the loved one dies, and my Self will lay flat under the gates, and my Shadow will stand above It, as an upside-down photograph, and my Ego as well lay in a coffin. Not to even start on the Animus evaporating. I mean i am not religious, but every time I don't get something in life, Jesus's words roll out as a riddle out of my memory, even though the first and the last time I read Bible was in my past life. Here! Left arm off! Not badging? Where is my sharper sword? Phew.... Thank You! I guess...
Mathew 10:35
The Sword of the Gospel
34 Do not assume that I have come to bring peace to the earth; I have not come to bring peace, but a sword. 35 For I have come to turn 'A man against his father, a daughter against her mother, a daughter-in-law against her mother-in-law. 36A man's enemies will be the members of his own household.'...

A person must pay dearly for the divine gift of creative life. It is as though each of us was born with a limited store of energy:

In the artist, the strongest force in his make-up, that is, his creativeness, will seize and all but monopolize this energy, leaving so little over that nothing of value can come of it. The creative impulse can drain him of his humanity to such a degree that the personal ego can exist only on a primitive or inferior level and is driven to develop all sorts of defects ruthlessness, selfishness ("autoeroticism"), vanity and other infantile traits. These inferiorities are the only means by which it can maintain its vitality and prevent itself from being wholly depleted
CW15 ¶ 158 .

AUTOEROTICISM IN CERTAIN ARTISTS IS LIKE THAT OF NEGLECTED CHILDREN

The autoeroticism of certain artists is like that of illegitimate or neglected children who from their earliest years develop bad qualities to protect themselves from the destructive influence of a loveless environment. Such children easily become ruthless and selfish, and later display an invincible egoism by remaining all their lives infantile and helpless or by actively offending against morality and the law
CW15 ¶ 158

IT IS HIS ART THAT EXPLAINS THE ARTIST

How can we doubt that it is his art that explains the artist, and not the insufficiencies and conflicts of his personal life? These are nothing but the regrettable results of his being an artist, a man upon whom a heavier burden is laid than upon ordinary mortals. A special ability demands a greater expenditure of energy, which must necessarily leave a deficit on some other side of life
CW15 ¶ 158 C G Jung.

There were the time I got a lot of money and we decided to rent a big house on Martha's Vineyard, off season. 9 months or so. Kontik loved it. Julie loved it. I was terribly depressed all the time. It was there that I read "Answer to Job" and after 6-month crying got into the house of sorrow. Where I met young puertorican Angel and had 6 years of romance, depression gone. I've noticed that all my near-death depressions based on the religious volcano in my soul. Or a rather big boom that opens my God's or gods or invisible powers faces from a different side, scary side, the side that doesn't make sense. As it is now. Yes, it's death in a family but the base is How could my God not only kill them but in the cruelest way? And that brings a lot of adjustments in order to survive... if it brings, but if one is stubborn and un flexible, then it only sways the floor.

Before an attack of painting, I was
passionate about fabrics. When I would
take them (millions) from all the drawers,
Kontik as you can tell was in shock and
looked as if to say: oh, no, she is doing
this again! ahahah

I found a bunch of pictures. On old Flickr account.
This is Marga, believe it or not. I am next to her with light hair. Her eyes are touched by the needle if you can tell.

For these earings, my teacher Marga called
me all bad names. And, she added, what's
up with the hair, falling who knows where.
I can't believe i just would say nothing.

Somewhere there my vitality collapsed. Still
trying to recover it.

Wounded teenagers of the Soviet Union
schools would leap out of them and get
married ASAP, partially because the
mothers couldn't feed them anymore, or
just because of the lethargic state of mind in
connection to young and desirable bodies...

Sveta Alenina . Borsh. Recepie:
cut everything first, potato small cubes, carrot - too, tomato,
onion, beats - thin peaces, cabbage - also very thin and beautiful,
no big peaces..

First sink potato, carrot, onion, salt in right proportion - most
important. Not enough - spoil everything. To add is not good
enough.
 i mean when it's cooked.

Sveta Alenina cabbage at the end - 4 min - add beats, only 2 min
- so that they don't loose color. Dill or what ever, i like dill,
cilantro .
garlic, to bite with good bread, good quality, expensive, and a
spoon of sour cream. lmmmmmm
oh shoot i forgot red pepper

(No location given.)
Dear Herr Hesse,

Naturally we shouldn't quarrel about words.
Nevertheless I would note in all humility that the
expression "sublimation" is not appropriate in
the case of the artist because with him it is not a
question of transforming a primary instinct but
rather of a primary instinct (the artistic instinct)
gripping the whole personality to such an extent
that all other instincts are in abeyance...
JL1 ¶ O . C.Jung. Letters.

Sveta F. Alenina

toomuchsveta@gmail.com
Svetabooks at Blurb.com

Valerientje

aan zee

Lightning Source UK Ltd.
Milton Keynes UK
UKRC010203311219
356143UK00009B/52